MAGIC LANTERN GUIDES®

MULTIMEDIA
WORKSHOP

Editor: Matt Paden
Book Design: Matt Paden
Cover Design: Thom Gaines Electron Graphics

10 9 8 7 6 5 4 3 2 1

First Edition

Published by Lark Books, A Division of
Sterling Publishing Co., Inc.
387 Park Avenue South, New York, N.Y. 10016

Photos © Rob Sheppard, pages: 3 (all except portraits), 4 (both), 5 (left), 6, 8 (bottom), 18, 20 (top), 21 (bottom), 22, 23, 24 (bottom), 25 (bottom), 30, 31 (bottom), 37, 49 (both), 54 (right), 55 (right); photos © Jeff Wignall, pages: 5 (right), 13, 21 (top), 27, 33, 36, 41, 44, 53; photos © Kevin Kopp pages: 9 (bottom), 10-11, 15 (top), 20 (bottom), 24 (top), 28-29, 32, 42-43, 47, 50, 51 (top), 54 (left), 55 (left) 56-57; photos © Matt Paden, pages: 19, 35; photos © Frank Gallaugher, pages: 39 (top), 51 (bottom); photos © Kara Helmkamp, page: 43; photos © istockphoto.com, pages: 3 (portraits), 25 (top), 42 (top), 46, 52; photo © Apple, page: 15 (bottom); photos © Canon Inc, pages: 9, 41 (top); photos © Nikon Inc, pages: 7, 8 (top), 17 (bottom), 28, 42 (bottom), 45; photos © Olympus Inc, pages: 38, 40; photos © SanDisk, pages: 9, 16; photos © Western Digital: 17 (top); photos © Joby, page: 39 (bottom left); photos © Manfrotto, page: 39 (bottom center & right)

Distributed in Canada by Sterling Publishing, c/o Canadian Manda Group,
165 Dufferin Street, Toronto, Ontario, Canada M6K 3H6

Distributed in the United Kingdom by GMC Distribution Services,
Castle Place, 166 High Street, Lewes, East Sussex, England BN7 1XU

Distributed in Australia by Capricorn Link (Australia) Pty Ltd.,
P.O. Box 704, Windsor, NSW 2756 Australia

Canon, Nikon, and other product names or terminology are trademarks recognized as belonging to their respective owners.

If you have questions or comments about this book, please contact:
Lark Books
67 Broadway
Asheville, NC 28801
(828) 253-0467

Manufactured in China

ISBN 13: 978-1-60059-578-3

For information about custom editions, special sales, premium and corporate purchases, please contact Sterling Special Sales Department at 800-805-5489 or specialsales@sterlingpub.com.

MAGIC LANTERN GUIDES®

MULTIMEDIA WORKSHOP

TAKING GREAT DIGITAL PHOTOS

LARK BOOKS

A Division of
Sterling Publishing Co., Inc.
New York / London

1 DIGITAL PHOTOGRAPHY BASICS

2 GETTING THE MOST FROM YOUR D-SLR

3 YOUR D-SLR CAMERA

4 CREATIVE CONTROLS

1

DIGITAL PHOTOGRAPHY BASICS

Digital SLRs open a new world of creative photographic possibilities. You can now change lenses and control functions like aperture and shutter speed to capture the images you've always wanted. Let's first look at some of the basics for shooting in digital with an SLR camera.

THE DIGITAL SLR

What is a D-SLR camera?

D-SLR (digital single lens reflex) cameras offer significant benefits over compact cameras. The two main advantages are their flexibility to change lenses and through-the-lens (TTL) viewing. TTL viewing lets you see the scene in the viewfinder exactly as it will appear in your picture. This is achieved by a mirror inside the camera body that reflects the scene in the lens up to the viewfinder. When the shutter button is depressed, the mirror flips out of the way and the light from the scene exposes the digital sensor.

The main advantage of the D-SLR over a point-and-shoot camera is interchangeable lenses, which allow for a huge range of optical flexibility and are the key to unlocking digital photography's creative potential. Specific lenses allow you to get the most of your subjects. If you're interested in shooting close-up or wide-angle photography, you can get lenses for those pursuits. If you like shooting sports or wildlife, you can buy super telephoto lenses that will allow you to capture amazing detail from a distance. Whatever your specific photographic goals, there are lenses to match them. For the new or average shooter, a decent zoom lens will usually offer enough flexibility to get started.

✂ **With a D-SLR, you can change lenses for more flexibilty and variety, and get-through-the-lens viewing for accurate previsualization.**

HOW A PICTURE IS FORMED

While a D-SLR still acts very much like a film camera in its mechanical operation, the exposure process going on behind the scenes is obviously quite different. The amount of technology packed into these small cameras, and the speed at which they work, is really an amazing technological feat. When light passes through the lens of a digital camera, it falls on the image sensor, which records the image. The surface of a sensor is covered in millions of microscopic light-sensitive receptors called photosites or pixels arranged in a grid pattern. Imagine a photosite like bucket; light falls into the bucket and its intensity is measured by a diode. Before the light falls into the photosites, it passes through a red, green, and blue color filter. These three colors create the primary spectrum, and with them, any color can be created. This filter is necessary because the sensor records light intensity only, and not color without assistance. Once the light passes through this color filter, it falls into the photosites and each photosite records one color. The camera then uses interpolation to combine the light and color information collected by each of the millions of photosites to create the image.

While all of this seems like an amazing digital feat, this process is, strangely enough, still an analog one. Digital cameras use an ADC, or analog to digital converter, to process the information collected by the sensor and turn it into the numerical information a computer can interpret. It is this information that is stored on your memory card.

✂ **Digital sensors like the one seen here capture and interpret light and color information to make great digital photos.**

QUICK START GUIDE

Use the following steps to get your camera charged up, loaded with a memory card, and ready to shoot for the first time.

A

1 You will need to charge your battery (A). Plug the charger into the wall and install the battery, following the manufacturer's instructions if necessary.

2 Attach the camera strap to the camera. You'll want to use this neck strap to help secure the camera if dropped and so you don't always have to hold it in your hands.

B C

3 With the camera turned off, insert the charged battery and insert a memory card (B). Format the card, if needed, following the camera manufacturer's instructions (see page 14 for more on memory cards).

4 Turn the camera on and set it to Auto mode. This is also sometimes referred to as Green mode, as many camera manufacturers use a green camera icon for this mode (C).

5 Use good handholding technique. Hold the camera's grip in your right hand with your index finger on the shutter button. Support the lens and body with your left hand and keep your elbows in, pressed gently against your body for additional support.

6 Shoot away! And get experimental— there's no worry about wasting film.

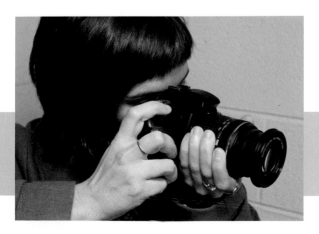

✄ **Be sure to use good handholding technique; doing so helps stabilize the camera for sharper images.**

MAKING SENSE OF RESOLUTION

With digital cameras, a lot of emphasis is placed on megapixel resolution. But what does this really mean? Resolution is the total number of pixels in a digital photo file and is stated as two numbers, for example 3000 x 2000 pixels (width x height). Multiply the pixels in the example and you get a total of 6,000,000 pixels, which equals 6 megapixels in the camera. This number is also known as area resolution. Resolution tells us how much data a camera captures, and the amount of this data determines the physical size of the image, and thus its print size. So a 12-megapixel camera is capable of making a larger print than a 6-megapixel camera. The good news is, unless you're a pro photographer who needs to make large prints for clients or art shows, you don't need the highest megapixel camera available on the market. Even an 8-megapixel camera, which is low by today's megapixel standards, is good enough for most amateur and hobbyist shooters.

One misunderstanding is that megapixels equal sharpness. This is not the case—you can have a very sharp image from a 3-megapixel camera and an unsharp photo from a 10-megapixel camera. You can also make 4 x 6-inch prints from 3-, 6-, or even 12-megapixel cameras and they will look essentially identical in sharpness.

Setting Camera Resolution

On your digital camera, you will probably see several resolution options available. Most of the time you should use the maximum resolution offered by the camera and stick to it—that's what you paid for, after all. You can always reduce the size of an image later, but increasing it to a larger size (that it could have been in the first place) will never give you the highest quality.

If your need is only to display photos on the Internet, you may find it easier and more efficient to shoot at a resolution that is less than maximum. This will give you smaller files that transfer faster, take up less space, and can be worked on quickly. But remember that if you ever want to make prints of these images later, their size and quality will be drastically reduced. Therefore, it's almost always best to shoot in the highest resolution and reduce the image size later.

✕ While it's true that more megapixels make a bigger print, an 8-megapixel camera is still large enough for most people's needs.

High-Quality JPEG

Low-Quality JPEG

✂ **D-SLRs can record several different compression levels (or quality levels) of JPEG files as well as RAW format (see page 12 for details). The top photo was taken with a High-Quality JPEG setting, which creates larger files by using all the megapixels in the camera. The bottom photo was taken with a Low-Quality JPEG setting. Since this setting uses less megapixels, image quality an bc affected, resulting in jagged, pixelated edges, often seen when cropping in close or displaying the image in a large format.**

FILE FORMATS

File formats can be confusing, especially since you'll hear some people say it is best to shoot in one format, while others tell you it is best to shoot in another.

JPEG

JPEG is an international standard for compression technology that offers a small file with superb detail. High JPEG compression (lower quality) settings create smaller files that fit easily on the memory card, although files can start to lose important data if overly compressed (see page 11). At low compression (high-quality) settings, most of the lost data can easily be rebuilt when the file is uncompressed. Bottom line: JPEG can work great, but it should be used at the highest quality settings most of the time.

Caution: Don't do your image editing with JPEG files! This "lossy" format loses image data each time you re-save. Open the JPEG files and save them in another format, such as TIFF, before you start editing.

TIFF

This is an ideal format for working with photographs in the computer because TIFFs don't compress data the way JPEGs do. But it is not ideal for the camera because TIFFs are large files that slow down cameras and hog memory card space, without the benefits of shooting in RAW. This is why few cameras still offer this format.

RAW

This file type uses data with minimal in-camera processing—interpreting the image just as it comes from the sensor. RAW offers more color data with its 16-bit file compared to the 8-bits of JPEG. This increased data can allow for greater adjustments and changes to the image file without problems occurring. RAW files are proprietary for each camera manufacturer so you'll notice they often have different file extensions. You need special computer software to read these files and to process them.

The Epic Battle

JPEG vs. RAW—the battle of the digital age. You will hear many photographers say you must use one or the other. It has even reached the point where I have heard photographers say that they don't want to use JPEG because it is an "amateur" format with poor color and tonality. That could not be further from the truth. JPEG files still offer plenty of creative control and create beautiful photographs. Still, several of my good friends in the nature photography industry would not consider shooting anything but RAW. They like the extra flexibility they get in processing the image after the shot.

What is important is the photography you do and your way of working. If you're on the fence, you can always shoot in JPEG + RAW if you're camera allows it, and see which format you prefer, or store the RAW files for later use. Just remember that this will use up space more quickly on your memory card.

✂ **Shooting in RAW offers lots of flexibility for adjustments. However, large file sizes and the need for special software make this a format best suited for computer-savvy photographers who enjoy working on their photos with image-editing software programs.**

MEMORY CARDS

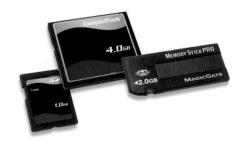

Memory cards are sometimes called "digital film" since they record images and can be removed from a camera like traditional film. While there are differences, thinking of a memory card this way is helpful. It is worth knowing a little about memory cards in order to get the most from them.

Memory cards come in a variety of sizes and shapes and the different types are not interchangeable. The type of memory card has absolutely no effect on image quality; it is simply a storage device. Many D-SLR models accept more than one type of card.

CompactFlash (CF) Cards

These are solid, reliable memory cards about the size of a matchbook. There is little that can damage CF cards. If you drop one in the mud or sand, clean it and plug it back in. Water will not hurt them, but high heat will.

SD and xD Cards

Many newer cameras now accept these cards, which are not much bigger than your thumbnail (xD cards are the smallest). They allow manufacturers to make cameras more compact. SD and xD are not interchangeable however, so be certain which your camera requires.

Memory Sticks

These are a unique type of memory card that Sony uses for its cameras. They look like a stick of gum and offer no advantages over other cards.

Memory Card Capacity

So how much storage should your card have? It depends on how you like to shoot. Below is a chart that shows how many photos fit on different sized cards. Keep in mind that shooting in RAW or RAW+JPEG will use more storage space.

If you want to try one of the really large, multi-gigabyte cards, make sure your camera can handle it. Do you buy a single big one and never change cards? But what happens if you lose or damage the card with all of your recent images? Perhaps a number of smaller ones would better meet your needs? There is no simple answer to this. It is more a personal preference as to how you would like to work.

IMAGE SIZE	Memory Card Capacity			
	512MB	1GB	2GB	4GB
4 MP	245	497	999	1998
5 MP	195	395	800	1595
6 MP	180	366	735	1471
7 MP	161	327	657	1314
8 MP	143	290	582	1164
10 MP	109	221	444	887
12 MP	83	169	339	678
	APPROXIMATE NUMBER OF PHOTOS			

DOWNLOADING MEMORY CARDS

Once you have your photos stored on a memory card, you will need to save them elsewhere. You will want to get photos off the card so they can be used in other applications, and also to clear your card for reuse.

Downloading from the Camera

Nearly all digital cameras offer the ability to transfer images directly to the computer with a connection from the camera. However, this may not be the best way to transfer data because it can deplete your camera's battery, among other factors. Downloading usually involves a cable (typically a USB connection), although infrared and other wireless technologies may be seen in all digital cameras in the future.

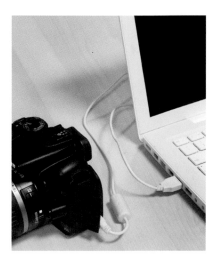

You don't need to remove the card from the camera when you use your camera for downloading. You simply connect one end of the USB cord to a USB port on the computer and the other end to the camera's USB port. When you turn on the camera, computers with the latest operating systems will usually recognize it and help you make the transfer. If your computer does not recognize the camera when it is plugged in, you'll have to install the camera's driver software on your computer.

Depending on what imaging programs you have on your computer, you'll often find one to help you move photos onto the hard drive. Many cameras come with image browsing software you can install if your computer does not already have a program you prefer. After you start the transfer process, the digital image files are copied from one place (your camera) to another (your computer).

> **Hint:** Pay careful attention to where these files are going. Too often the files end up somewhere on the hard drive—but where? If it is not clear, the program will usually tell you in Options, Preferences, or Tools.

❖ **Many image-browsing programs, like Apple's Aperture or iPhoto, help in the download process.**

CARD READERS

I strongly recommend a card reader for downloading. This is the fastest and simplest method. A card reader is a small, stand-alone device that plugs into the computer's USB port, and it has a slot for your camera's memory card. Many of these devices will read multiple card types — this can be a real benefit if you have more than one camera and they use different cards. Otherwise, you will probably just want the simple, less expensive unit that only reads the card type that your camera uses.

A card reader is easy to use and very affordable. In a way, it makes your camera act like a traditional film camera. You simply take your "digital film" out of the camera and put it into the slot for "processing." The computer will recognize the card as a new drive (again, on some older operating systems you may need to install a driver for the card reader, which will be included on software that comes with the unit).

The card reader now allows you to manage the image files. If you are not familiar with how computers deal with files, transferring images may take some learning. But if you have even basic computer skills, you will find that this reader now allows you to work with the image files just as you would any other files — like selecting all the photos on the card and copying them to a new folder on your hard drive.

The process I recommend for downloading pictures is pretty simple:

1 Set up a folder on your hard drive to hold your transferred photos (you can name it something related to your photos, such as Soccer Tournament July). Most computers have a Photos folder already set up on the hard drive. If you don't have your own filing system, you may want to save the photos in subfolders here.

2 Plug in your card. When the card icon appears on your desktop (maybe with a downloading wizard), open the folder and find the photos.

3 Select all of the photos: Command A (Mac) / Control A (PC).

4 Drag and drop them to the folder you set up for your transferred photos. This will copy the images to the new location.

5 Use an image browser program such as ACDSee or iPhoto (Mac) to review, edit, and sort your photos.

You've downloaded your images. Now let's review what is the best way to erase images from the memory card.

CLEARING THE CARD

Erasing and Formatting the Card

When a memory card is erased, no image files are actually destroyed or removed from the memory. Erasing removes only location/identification data that tells the computer where the file is located. Once this location/identification data is removed, new photos can overwrite the old image files. Once new photos are saved, the original photo is "lost" since its information has been overwritten. When formatting, the camera completely rebuilds the directory structure of the card (which tells any device reading the card how to find the data). This results in the erasure of the photos by removing locating links to the actual data. Always use the camera for erasing and reformatting of the card. Formatting your card in the camera lowers the risk of corrupting or accidentally changing the file system of the card.

✖ **Use an external hard drive for backup.**

Long Term Storage

Your computer's hard drive should not be considered a unit for long-term storage. Computer hard drives crash and fail all of the time, and you could lose your entire image library. External hard drives are one option for backing up files, but these can become corrupt too. Your best bet is to think about long-term archival storage for your most important photos—and this is best accomplished by burning them to CD or DVD.

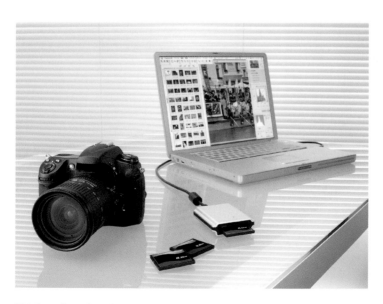

✖ **When done downloading your images to the computer, put the memory card back in the camera to erase all of the files.**

CHAPTER 2

2

GETTING THE MOST
FROM YOUR D-SLR

It pays to gain a certain level of understanding about different camera functions and accessories. You don't have to become a "professional" to enhance your camera's (and your) ability to shoot good photographs, but it helps to comprehend and appreciate the fundamentals.

AUTOFOCUS (AF)

Autofocus performance has a number of important attributes: speed; single or continuous focus; number and location of sensors; and AF light sensitivity. Advanced cameras are usually better in these repects, but this is not simply a matter of camera price, since newer AF technologies often enable lower-priced cameras to beat older, more expensive cameras.

Speed and Type of AF

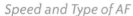

Speed of the camera is affected by the type of autofocus selected: single or continuous. In single-exposure autofocus, the camera will usually not take a picture unless the autofocus has focused on something, which is fine for most shooting but can be a problem with moving subjects. Continuous focus lets the camera shoot as it is focusing. Most D-SLR cameras even use something called predictive AF or focus tracking that allows the camera to keep up with the action.

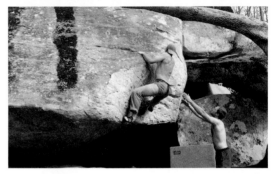

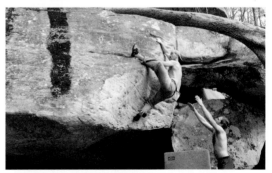

 Use the Continuous autofocus mode when shooting sports or activities where you want to capture the action quickly.

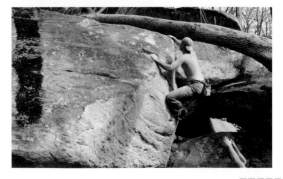

AF Sensor Location

Location of the actual focusing sensors in the image area also affects how the autofocus will work. More advanced cameras will have either a group of sensors across the viewing area or variable sensing over the whole scene, which makes it difficult for the subject to elude detection. Most, if not all, D-SLR cameras let you select the AF sensor for specific areas to match a composition you want.

AF Considerations

One last thing to consider is how bright the conditions are. Low-light or low-contrast subjects can make it very difficult for the camera to autofocus. Most cameras have AF assist beams that operate in dark conditions. Be aware that these can be inappropriate for some locations (where a bright burst of light in the dark would be rude or even dangerous).

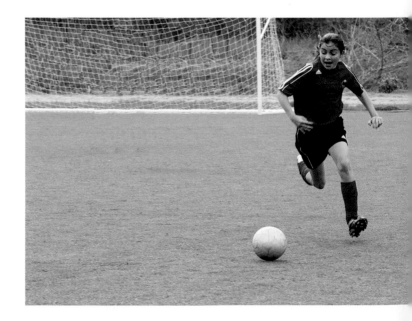

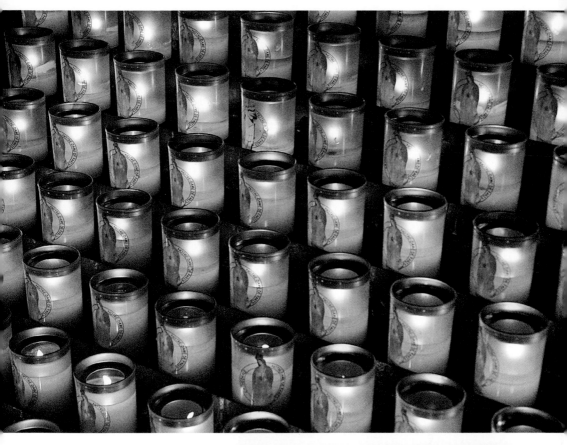

✖ These candles were shot in the Notre Dame cathedral in Paris. The flash and AF assist light were turned off to eliminate the rude burst of light.

EXPOSURE

Autoexposure has become so sophisticated that in order to get poor results you almost have to try to shoot a bad picture. Cameras and their metering systems really do their job remarkably well. However, sometimes a "good" automatic exposure from the camera isn't actually the best exposure for the subject. To get an exposure that truly expresses your intent, there are things you can do to transform a good exposure into the great image you want.

Understanding Meters

A camera's meter is calibrated to expose all scenes as middle gray, or average. It can't really tell if a scene is filled with objects that are light, midtone, or dark. Ideally, under the same lighting conditions, the meter should expose all the objects equally. Unfortunately, the meter will in fact give different exposures, making light objects too dark and dark objects too light. To compensate, camera manufacturers have developed sophisticated systems for metering that include multiple metering points and computing analysis. These systems get more sophisticated as the price of the camera goes up.

Exposure Compensation

For most photographic situations, the camera's smart metering system offers excellent exposure. Problems occur when the scene is mostly very dark or very light, when there is extreme contrast in the scene, or when a bright light (like the sun) shines into the lens, especially when it is near an AF focusing point. Once you understand how your meter reacts to light, you can use the exposure compensation feature to make a quick adjustment and continue to shoot. Exposure compensation allows you to increase or decrease the camera's autoexposure in small steps (usually in 1/3- to 1/2-stop increments, and you can often change these increment settings in your D-SLR).

✕ **Highly contrasting parts of a scene can make it difficult for your camera to get a balanced meter reading. Use the exposure compensation settings or exposure lock for more accurate results.**

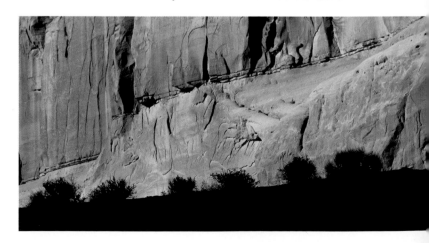

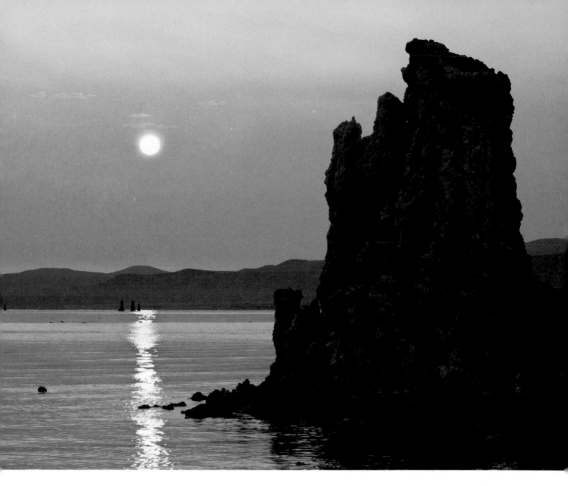

Exposure Lock

Most digital cameras will lock exposure on whatever they see if you depress the shutter release slightly (usually about halfway) or depress an exposure lock button. This is another way to quickly "compensate" for problem scenes.

For example, suppose you were shooting a sunrise, but a large part of the scene had a darkly silhouetted rock. In addition, the camera focused on the rock. That large dark area connected to the focus point would likely throw the meter off, resulting in the sunrise starting to lose color (from too much exposure).

To overcome this problem, move the camera so it sees more sky and less rock, and lock the exposure at a point in the sky where color will be improved in the image. Then reframe the picture like you wanted in the first place using the exposure settings from the more brightly lit part of the scene. The picture you take should now show more accurate colors in the sunrise.

EXPOSURE MODES

Most D-SLRs offer multiple autoexposure modes that use the information provided by the metering system to give you a good exposure. These modes feature approaches to exposure that meet the varied needs of photographers. You probably won't use them all, but it's good to familiarize yourself with them so you know what your camera offers.

Full Auto and Picture Control Modes

Sometimes called a "point-and-shoot" or "green" mode, full auto mode is offered on most D-SLRs. Full auto rarely allows exposure compensation or any other adjustments. This is a great mode for casual family snapshots or vacation photography.

Many cameras also include special full auto modes sometimes called Scene modes, which are designed to work with specific subjects such as Portraits, Landscapes, Macro, etc. These usually affect more than just the exposure, including settings such as flash, focus, and aperture.

Portrait: This mode favors wide lens openings and is best used with longer "portrait" focal lengths (around 75mm) to render the face in soft-focus with diffuse backgrounds.

Action or Sports: Fast shutter speeds are chosen to stop action (Figure 1).

Landscape: Designed for scenic photography, this mode selects small apertures and is best used with wide focal lengths for maximum angle of view and depth of field (Figure 2).

Flash Off: This mode is helpful for long exposures without flash.

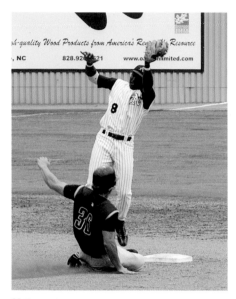

✖ Figure 1

✖ Figure 2

Night Portrait or Slow-Sync Flash: These modes balance the foreground flash and existing-light background exposure so that backgrounds do not appear dark in the photo. It is also useful for more than night photography—try it on people on a gloomy, cloudy day, for example.

✕ Figure 3

Face and Smile Detection: Camera manufacturers are beginning to include these technologies in both mini digital cameras and high-end digital SLRs. Face detection cameras scan the scene, searching for two eyes, a nose, and a mouth—when it recognizes a face (or faces) it will automatically adjust exposure and focus to provide the best conditions for a portrait. Some of the higher-end cameras can recognize 10 to 15 faces in a scene. It will also ignore smaller faces meant to fade into the background. Smile technology takes this concept one step further—when the camera detects a grin or a laugh from your subject, it automatically takes a picture. Both of these features can be turned off for non-human subjects (Figure 3).

Close-Up: This mode sets a moderate aperture to balance a faster shutter speed (to minimize the effects of camera movement) for close focus work (Figure 4).

✕ Figure 4

Many digital cameras offer additional, more sophisticated exposure modes which give the photographer more control.

Program Mode (P)

The camera sets both the aperture (lens opening) and shutter speed for you. If your camera allows Program Shift, you will be able to quickly change the camera-selected shutter speed and aperture combination while maintaining an equivalent exposure (see page 45).

Shutter-Priority Mode (S or Tv)

You select the shutter speed and the camera sets the aperture for you. This allows you to control how action is rendered in the photograph. A fast shutter speed will stop action nicely, and is also useful in lowlight conditions to reduce blur. Long shutter speeds can be used to get interesting effects like the pillowy look of moving water popular in many waterfall shots. When using long shutter speeds, it's best to use a tripod to minimize the camera shake that can blur photographs when hand-holding the camera.

Aperture-Priority Mode (A or Av)

You set the aperture and the camera chooses the shutter speed. This gives you control over depth of field. All else being equal, smaller apertures (larger f/numbers) maximize depth of field, giving you the ability to have sharper detail in more parts of a photo. However, you must be aware of the shutter speed the camera is selecting to prevent the possibility of unsharp pictures due to camera movement. Use large apertures (smaller f/numbers, like f/2.8) to experiment with shallow depth of field in portrait or close-up shots.

Automatic Exposure Bracketing (AEB)

This feature can generally be used with Program, Shutter-Priority, and Aperture-Priority modes. The camera's exposure bracketing system automatically varies exposures in a series of three photos when the shutter button is depressed. These will deviate by a set range from the metered value. Normally, one exposure is lighter than the metered value (more exposed), one is taken at the metered value, and the third is darker (less exposed). This gives you exposure choices in the finished images.

Manual Exposure (M)

Manual exposure is useful when you have tricky lighting, when shooting panoramic photos where side-by-side photos must match, when you are trying to blend flash with existing light, or for creative effects.

Some cameras offer several metering options for Manual mode, like center-weighted and partial metering. Center-weighted systems favor the meter sensors in the center of the photo, then decrease in sensitivity toward the outside of the frame. Partial or spot metering focuses on a small spot in the image area (usually the center).

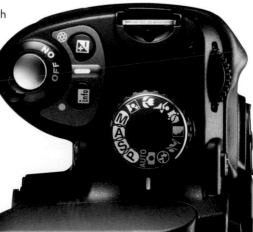

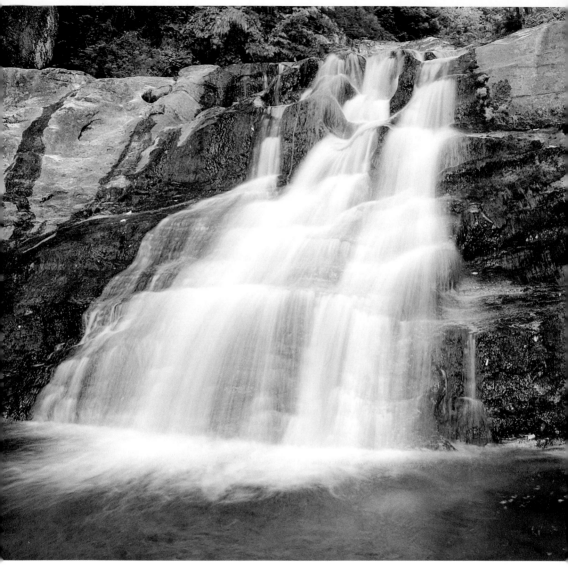

✂ **Use Shutter-Priority mode to set long shutter speeds to slow down motion. The camera will set the aperture for you based on the light meter's reading to give you pleasing results.**

Beyond "Good" Exposure

The best exposure for a digital camera is the one that gives you the best image/data for your intended purpose. If you want to make a great print, you need to have the appropriate exposure data for highlights and shadows.

Also important is how exposure affects the subject. A dramatic but dark mountain might look weak and washed out when shot with a basic autoexposure mode. Similarly, a bright beach might look dim and less than sunny with a standard meter reading. You need to interpret your exposures, which can be done as you gain experience in judging how the light will be interpreted by the metering system and by reviewing images on the camera's LCD screen.

One of the truly great advantages of digital cameras is their ability to let you review exposure on the LCD. It can quickly tell you if a scene is so contrasty that you cannot capture all the possible detail. It will show you if the subject has been captured appropriately: Are the dark trees dark and white buildings bright? Reviewing images you just shot will give you ideas about changing the exposure to match the needs of the scene. It helps you decide if the photograph is going the way you want it to. If you enlarge the image, you can usually see if detail exists in highlights or shadows.

However, there will be situations when the little LCD monitor isn't as ideal as you'd like for evaluating exposure. That's when the histogram should be used. The histogram is a graph that tells you about the exposure levels in your shot. For photographers who are new to digital, the histogram's techy-looking graph can initially be confusing or even intimidating. My suggestion is to try it! At its basic level, the histogram is simply a graph of the number of pixels with specific brightness values from dark (on the left) to bright (on the right). With just a little practice, the histogram is fairly easy to understand.

✖ **Use your LCD screen to interpret exposures for the scene you are shooting.**

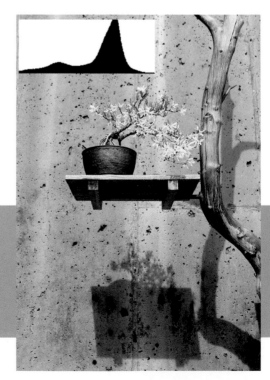

✖ **This picture is properly exposed. Note how the histogram is balanced in the middle of the graph, while the sides gently slope downward. This means that no shadow or highlight details are lost.**

How to Interpret What You See

A good exposure of an average scene will show a histogram without an imbalance of brightness values on one side or the other. The range of tones for important brightness areas of a photograph should finish before the end of the graph at one side or the other. Whenever the histogram stops like a cliff instead of a slope at the sides, it means the exposure is "clipping" detail. If detail is important for dark (left) or bright (right) parts of the photo, you need to adjust exposure to bring the slope of the histogram back into the graph.

How the detail in the histogram is arranged can also help you evaluate your exposure. If you're photographing a bright scene, the histogram should show most of the values to the right, where bright values are expected in a histogram. Since bright subjects can be easily underexposed, those values may at first sit to the left half of the histogram. This is the wrong place for them. For dark scenes, the story is similar—these values belong on the left. The graphed values should reflect the scene. Use exposure compensation and retake the picture to shift the histogram to the right or left.

�খ **This photo is overexposed. Highlight detail is blown out—this shows in the histogram, which is clipped to the right. The gap in the graph at the left shows that the blacks appear gray in the photo.**

✖ **This photo is underexposed. Shadow detail is lost and the histogram is heavily weighted to the left, with obvious clipping of the dark areas occuring.**

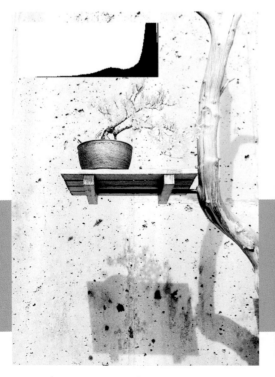

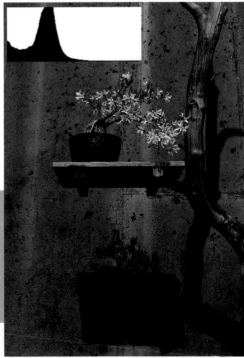

3

YOUR D-SLR CAMERA

Digital cameras have many new features compared to their film counterparts, such as adjustable ISO and white balance, which can truly enhance your picture-taking experience. This chapter will offer you a quick overview of what your D-SLR has to offer.

ISO SETTINGS

Digital cameras offer the ability to change ISO settings as you go. Choosing higher ISO numbers increases the sensor's sensitivity to light, allowing you to shoot in darker conditions. Here are three key things to consider when choosing ISO speed:

Image Quality

Low ISO settings usually produce clean images with fine detail, good color and tonality, plus little or no noise (noise is like film grain; see page 32). For optimum image quality, use the lowest ISO speed possible because noise increases as ISO speed increases. However, there are times that a higher ISO speed will make the difference in getting or not getting a shot—always go for getting the picture and worry about noise later. Higher ISO settings on new D-SLRs are less affected by noise thanks to better sensors (with bigger photosites) and new noise control engineeering strategies.

Shutter Speed

Higher ISO settings allow you to use a faster shutter speed. This can be extremely helpful when handholding your camera. Faster shutter speeds will also freeze action better.

Flash Range

With any given flash unit, whether built-in or accessory, higher ISO settings will give you more range. Lower ISO settings usually make fill-flash easier to use in bright conditions because they allow the flash to be less obvious in the exposure.

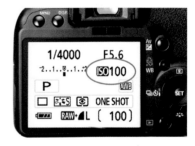

✕ It's easy to change ISO on a D-SLR. Look for the settings on the LCD screen or on a dial.

✕ Using lower ISO settings will result in excellent quality, noise-free digital photos like this one.

Noise in an image is seen most easily in large, smooth-toned areas such as sky. It appears as tiny specks of random color and light, which can obscure fine detail and alter colors. In addition to increased ISO settings, there are several common sources of noise.

Sensor Noise

You have no control over the sensor itself (more expensive digital cameras often control noise better in their processing circuits). However, if you shoot in bright light and restrict the use of higher ISO numbers, you will minimize the noise in the image from the sensor.

Exposure

It is important to expose images well so that dark areas have enough data for you to work with. Underexposed areas are very susceptible to noise.

✂ **Noise appears as tiny specks of random color and light that look like grain. It shows up strongly in even-colored areas of the image when high ISOs are used.**

JPEG Artifacts

Utilizing a JPEG compression in the camera that is too high, or repeatedly opening and saving a JPEG image in the computer, can create blocky details that look like chunky grain—noticeable in areas that have slight gradients of tone, such as sky. Set your camera to its best quality (lowest) compression.

Sharpening

Sharpening in the computer can overemphasize noise. All too often, when the entire photo is sharpened, slight noise suddenly gets very ugly. When possible, sharpen only the well-focused parts of the photo.

Image Processing

Image-processing software can increase the appearance of noise. Overuse of Hue/Saturation, for example, will dramatically bring out undesirable grain, so use the software's preview and watch for unwanted noise. Avoid over-processing of an image's color.

✂ With night photography, it is often best to use a medium or high ISO
setting to capture a scene, even if there is a decent amount of ambient
light. You may encounter problems with noise in the image, but it's
always better to take a chance and get the shot. Often, noise in pictures
can be corrected, or at least lessened, with computer software.

THE WHITE BALANCE FUNCTION

A new concept for most novice photographers, white balance (WB) is important to understand because it can affect the final appearance of a JPEG photo (WB in RAW files is more easily modified), and it can be both a corrective and creative tool. Once you see the benefits of using white balance, you will be glad that you have mastered it.

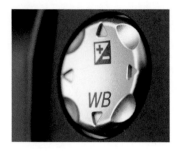

X Use white balance to accurately capture color.

The Color of Light

Our eye-brain connection makes most types of light look neutral so that colors stay consistent. A white shirt looks white to us whether it is in the shade, in the sun, or indoors under fluorescent lights. Yet, those three lighting types have very different inherent color, which causes color shifts in photography. To keep colors looking as they should in different types of lighting, digital cameras use the white balance control.

How the Camera Adjusts

To achieve white balance, the camera looks at the white and neutral colors of a scene, either automatically or with your help, and makes them appear neutral. This control renders color accurately, making it look correct in a scene regardless of the light source, whether indoor fluorescent or mid-day sun.

But sometimes it can go too far, making the warm light of a sunset, for example, technically "correct" yet lacking the dramatic warmth we expect in a good photograph of a sunset. It is true that you can make color adjustments in the computer, and if you shoot RAW images, you can totally change white balance after the fact. However, in most cases it is best to adjust your white balance while you are shooting.

Automatic White Balance

Automatic white balance can be useful for shooting quickly in changing light conditions; however, I rarely select auto as my standard. The auto setting often gives inconsistent results simply because it is an auto function that is making the best of a world that varies in terms of color and light.

Pre-Programmed White Balance

All digital cameras have pre-programmed white balance settings. To get the most from these, think beyond the setting's specific name; you may find that your camera does a nicer job using one setting over another in different lighting situations. Try the different options on the same subject (like the series of photos on the opposite page) to see what they do and think how you might use them to enhance a scene's color. The camera's LCD can help you roughly judge how the different settings affect a particular scene. It is true that the monitor on the camera isn't that accurate for judging all colors, but it can give you an idea of what the colors are in a given situation.

☀ **Sunny WB**

☁ **Cloudy WB**

☀ **Tungsten WB**

▨ **Fluorescent WB**

�֎ This series was taken using different white balance settings and it was shot outdoors on a cloudy day. Note how the picture taken with the Cloudy WB preset has the most natural-looking colors.

White Balance as a Creative Tool

You can also change the response of the camera to various situations so that color is rendered warmer or cooler for creative purposes. In this way you can create a sunset that looks more like you expect it to look (use the Cloudy or Flash settings). Also, you can intentionally make a cold winter day appear even colder (try Tungsten). Experiment with different white balance options and check your LCD to see what they do to the picture.

Manual White Balance

Called "custom" or "preset" by different camera manufacturers, Manual white balance can be very helpful to precisely match a given lighting condition.

To use Manual WB, point your camera at something white or gray (it does not have to be in focus) and follow the procedure for color balancing. (This varies from camera to camera, so read your manual.) The camera analyzes the specific white or gray tone and adjusts the color so that it is truly neutral. This can give quite remarkable results in tough situations with lights such as industrial fluorescents.

RAW and White Balance

Finally, shooting in RAW increases color balance options. RAW files give you the ability to go back and change your original white balance choice. This helps compensate for the inconsistencies of automatic white balance, but it requires more processing work. This will mean you can get much better consistency with multiple images. However, this should never be an excuse for not setting white balance as best you can before taking the picture.

MAXIMIZING IMAGE SHARPNESS

Many photographers get less sharpness in their images than their equipment is capable of delivering. This is really a shame considering the high quality of lenses today, and it results from a very common problem: slight camera movement during the exposure. With a good tripod, this doesn't happen. When you are handholding a camera, it can move or shake, especially with small, lightweight digital cameras. A fast shutter speed will "freeze" the movement to maintain sharpness, but with longer shutter speeds, blur will begin to occur at some point.

Just because a digital camera is easy to handhold doesn't mean it will automatically produce its best results that way. Unfortunately, a small LCD screen can be very misleading for judging sharpness. To accurately judge sharpness, magnify the image (use the magnification feature of your camera). The best way to see how sharply your handholding technique captures an image is to compare the handheld shot to a photograph taken with the camera locked on a tripod.

The solution when you are handholding? Use fast shutter speeds. This can be a problem when photographers shoot on full auto mode and assume the camera is selecting an adequate shutter speed. Often, a slower shutter speed may be selected by the camera. This slower shutter speed may be the cause of unsharpness from handholding.

Many digital SLRs now offer image stabilization (IS) technology, which is called by different names depending on the manufacturer. Originally found in high-end lenses, this technology may also be found inside the camera body, where it helps to reduce camera shake and allows consumers to buy less expensive, non IS lenses. Depending on conditions, IS technology can allow you to handhold the camera at 2-1/2 to 4 shutter-speed steps longer than a camera without it, which would need to be mounted on a tripod to achieve the same effect.

Magnify your images often when reviewing them in the LCD; it's the best way to make sure your photos are sharp.

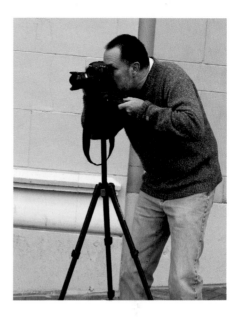

⊠ Essential for close-up work or long exposures, a good tripod is one of the best equipment investments you can make. A tripod will help reduce the blur common from handholding a camera and let you get tack sharp photos.

Camera Supports

When light levels drop, or you are using long telephoto or macro lenses, it can really help to use a camera support. Because digital cameras can be so comfortable to handhold, it is easy to get lulled into the idea that you don't need a camera support.

You can get very handy, compact tripods for digital cameras that will fit in a carrying bag. These are small, but they can be set up anywhere—on a table, a rock, against a wall, and so forth, and they'll help a lot. Bean pods are quite handy little devices that fit in most camera bags. They provide a soft medium that cushions and stabilizes the camera on a hard surface, such as against a railing or fence post.

There is no question that tripods will help you get the most out of your camera and lens, but you need to invest in a good one. A cheap, flimsy tripod can be worse than none at all. And don't look for a tripod with a long center column—they are extremely unsteady.

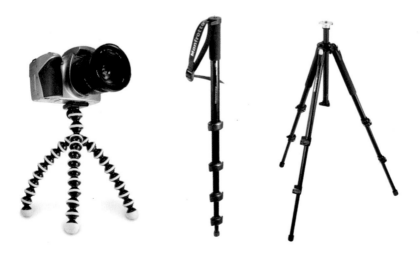

⊠ A variety of camera supports are available depending on your needs. From left to right: A Joby Gorillapod, a monopod (which doubles as a walking stick), and a tripod.

LENSES

Since the ability to change lenses is the greatest benefit of a D-SLR, it pays to understand how different lenses help your photography.

Focal Lengths

Typically, lenses break down into four categories based on focal length: normal, wide-angle, telephoto, and zoom.

A normal lens has a focal length of around 50mm and sees a scene similarly to how the human eye would view it. A lens below that focal length, like a 28mm lens, is considered wide-angle because it can take in a much broader view of a scene than a normal lens can, making it great for landscape photography. Anything with a focal length greater than about 85mm is considered to be a telephoto lens, and is great for magnifying distant subjects. A zoom lens incorporates a range of focal lengths into one lens, like 28–105mm for example, making it convenient and flexible in the field.

The term "angle of view" refers to how broad the field of view is that a lens can capture, i.e., a wide-angle lens sees a wide angle of view, whereas a telephoto sees a narrow field of view. You should choose your lenses based on this criterion: How much of a scene do you want to appear in your photograph? If you are undecided or you know that you want to work with a variety of subject matter, you may consider using a zoom as your primary lens, as do the majority of hobbyists and serious amateur photographers.

✕ **Most camera manufacturers offer complete lens systems, from wide-angle to super telephoto, and everything in between.**

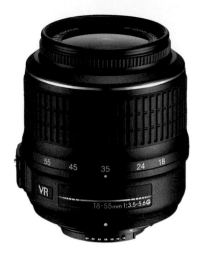

✂ Lenses are labeled with their focal length and aperture size. This zoom lens features an 18–55mm focal length, and its aperture range is f/3.5–f/5.6.

35mm Equivalents

The photo industry uses an important convention to talk about lens focal lengths with digital cameras: 35mm equivalents. A lens' focal length is meaningless without a reference to the image area, or sensor, within the camera. Different digital cameras have different-sized sensors, and it's the physical size of this sensor that determines the angle of view at a given focal length. This makes any comparison of focal lengths between two different cameras a real challenge unless there is some direct baseline for comparison. This baseline is the 35mm equivalent, giving a number that shows what a lens offers compared to the same angle of view as a lens on a 35mm camera. To give an example, a camera's zoom lens may physically be an 18–50mm focal length, but if the camera's sensor is APS-C format (and thus smaller than 35mm), it will act like a 27–75mm lens would on a 35mm camera. Converting the numbers to 35mm equivalents helps photographers make sense of their lenses because so many people still understand focal lengths in relation to 35mm cameras.

Lens Speed

Lens speed refers to how much light a lens lets into the camera at its widest aperture, or its maximum f/stop (smallest f/number). This is the number that is always given when referring to a lens and its focal length. For example, a lens with a 35–105mm (35mm equivalent) f/3.5 would be a zoom lens with a maximum aperture of f/3.5. The wider the aperture, the faster the lens. So an aperture of f/2.8 is larger than f/3.5, thus letting in more light and allowing for faster shutter speeds. This helps when you need to shoot action, obviously, but it also helps when the light gets low.

Depth of Field

Depth of field is the range of sharpness from front to back in a photograph. It is what allows you to have both a flower in the foreground of a photograph and the mountains in the background in sharp focus. Four things influence depth of field: f/stop, focused distance, focal length, and print size (for more on depth of field, see page 48).

Flash units are built into almost all D-SLRs, plus you can add an accessory flash unit to your camera's hot shoe. Both manufacturers' and camera brand-specific units marketed by independent companies work with all the bells-and-whistles you'd expect in a modern flash unit. (If you are not sure if a unit will work with your camera, check with your photographic dealer.)

You may be surprised at how much you can do with a built-in flash. You have a secret weapon compared to the days of film: Take a picture and check it! Your digital camera shows you the image on the LCD so you can evaluate and reshoot, if necessary.

Basic Flash Exposure

The digital camera will send off a burst of light called a preflash an instant before the flash exposure actually occurs. The preflash allows the camera to determine the exposure. This happens so fast that most people don't notice. For the actual exposure, the flash emits a specific duration of light and cuts itself off when the proper amount of light has been cast.

Red-Eye Reduction Flash Settings

Red-eye in flash photos of people is distinctly unattractive. It occurs in dark situations when flash is used. The red-eye reduction function will cause a preflash to occur, making the subject's iris narrow. While this is helpful, it can also create photographic problems. Often the subject will react poorly to this preflash, so the photos may show less red-eye, but the person's reaction creates an unflattering picture.

You can also get rid of red-eye by using an accessory flash. This larger unit is farther away from the axis of the lens and is better positioned to reduce red eye. In addition, many software programs now include easy-to-use red-eye reduction tools that allow you to take the shot and not worry about red-eye.

✂ **With digital photography, you have many options in winning the battle against red eye.**

Flash Options

Most photographers use a flash aimed directly at the subject. This direct type of flash is useful when you need to see things in dark conditions or when your subject is some distance from you, as with sports or wildlife photography.

Another use of direct flash is fill flash. This allows the flash to brighten shadows in very contrasty light. It is an ideal use for a built-in flash. Watch people taking pictures of each other on a bright, sunny day. Notice that contrasts create strong shadows on faces and under hat brims. Yet, although most of these people have cameras with a built-in flash, the photographer rarely turns it on. Almost every digital camera can have the flash set so it flashes at all times. Again, the great thing about this technique with a digital camera is that you can always see the results and there is no cost to experiment. Try turning on your flash in harsh or even gray-day conditions and see what you can get.

Unfortunately, a lot of indoor flash photos look like those deer-in-the-headlights paparazzi images. This type of lighting isn't flattering to the subject and can produce harsh, rather unattractive photographs. There is one thing you can do with your built-in flash to avoid this: allow some existing or ambient light to be exposed in the background. (Check your camera's manual to see the best way to do this. If your camera has a slow-sync or night flash setting, try that.) This immediately makes the flash look less harsh.

High contrast conditions are a great time to use fill flash. The top image, shot without flash, resulted in a silhouette. Fill flash was used in the bottom photo, which reveals the details in the foreground.

If you can use an accessory flash unit, there is a very easy way to get better photos: bounce flash. It can be used with any flash that tilts, or with off-camera flash. Here, you point the flash at a white surface (ceiling, wall, reflector, etc.). This spreads the light out and softens its edges. It can be a very attractive and natural-looking light for interiors and is especially effective when photographing people.

4

CREATIVE CONTROL

Understanding your camera's features and functions is the first step in learning how to take great pictures. Once you get a handle on those fundamentals, you can begin to use them as creative tools to interpret a scene according to your vision.

There are two settings on the camera that have the biggest effect on the creative control you have over your images: aperture and shutter speed. The aperture setting controls how wide the iris of the lens will open when you take a picture, and the shutter speed determines the duration of the exposure. A smaller f/number means a larger aperture opening, and the smaller fractions represent faster shutter speeds. Thus, f/5.6 is bigger (more light) than f/8; and 1/500 second is faster (less light) than 1/250 second.

Reciprocal Exposure Settings

Before we get into the specifics of aperture and shutter speed, it's important to understand that these settings have a reciprocal relationship. What does this mean, exactly? Simply put, it means that you can get a good, accurate exposure of a scene using a wide range of aperture and shutter speed settings,

as long as a change in one is compensated for by an equal and opposite change in the other. If you have tried using the aperture-priority (A/Av) or shutter-priority (S/Tv) mode on your camera, where the aperture and shutter settings are linked and a change in one automatically creates a corollary change in the other, then you have already been using this concept—you just might not have understood exactly what was happening.

Let's take a closer look at why this works. When you change an aperture or shutter speed setting in your camera by one stop, you are either halving or doubling the amount of light entering the camera and exposing the sensor. For example, if you increase the aperture setting by one f/stop, you have doubled the amount of light reaching the sensor. If you decrease the aperture by one f/stop, half the amount of light is now reaching the sensor. This same math holds true for increasing or

decreasing shutter speeds. And since a change in either aperture or shutter speed alters the amount of light entering the camera at the same rate, reciprocal changes to their settings will balance each other and deliver proper exposures. In effect, you are trading the amount of light (aperture) with the duration of light (shutter speed) hitting the sensor. As long as you account for a decrease in the amount of light with a longer duration of light (and vice versa), your picture will still be properly exposed.

This fact becomes important when you want to adjust your shooting for a specific look. Say you are trying to photograph your dog running after a ball in the park. Your meter might suggest a normal exposure like 1/125 second at f/11, but you'll need a faster shutter speed like 1/500 second to get a sharp picture of your pup because he'll probably be blurry due to motion at a slower shutter speed. If you were to change the shutter speed setting to 1/500, not adjust the aperture, and take the picture, your image would be two stops underexposed. That's because the faster shutter speed let in less light while the aperture setting was still the same. So, the obvious fix is to open the aperture wider to get more light to the sensor. By raising the aperture two stops to f/5.6 in conjunction with the two stop decrease in the shutter speed, you'll now get the same exposure the meter suggested—only now, your pooch will appear sharp as he jumps for the ball thanks to the fast shutter speed.

✂ **Opposite Page: This static architectural scene allows for slower shutter speeds since there is no subject motion. In order to get as much of the interior mall in focus as possible, a narrow aperture was required to increase depth of field. Instead of using the camera's suggested combination of f/4 and 1/125, this scene could also be properly exposed at 1/30 second using an aperture setting of f/11.**

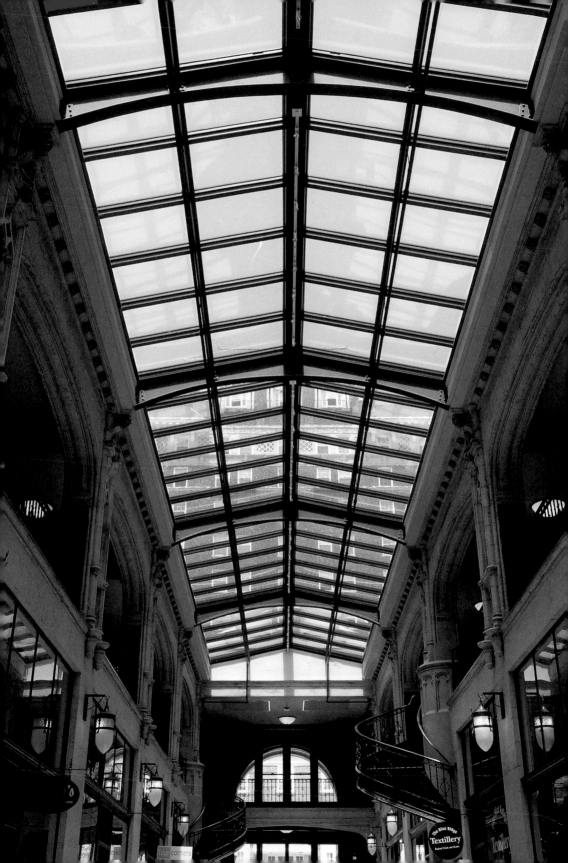

Aperture

A camera's aperture is the size of the opening in the lens diaphragm that allows light to pass through to the sensitized media, such as a digital camera sensor. In recent years, shallow depth of field has been very popular in magazine and book photography. By now, everyone is familiar with the look, where a close-up picture of, say, a cupcake, shows the cherry and frosting in sharp focus while the plate, cups, and other parts of the scene appear soft and slightly out of focus. Aperture settings, called f/stops, help to control this effect, whether you want the type of shallow depth of field described above, or large depth of field where everything in a landscape, from a flower in the foreground to mountains miles in the distance, appears equally sharp.

There are several different ways to control depth of field:

1. **f/stop:** Small apertures (higher f/numbers, such as f/11) increase depth of field; large apertures (lower f/numbers, such as f/2.8) decrease depth of field. So, if you want the background to be out of focus, try using a large aperture like f/2.8 or f/4. If you want to maintain sharpness throughout your image, from foreground to background, use a small aperture like f/11 or f/16.

2. **Focus distance:** The farther you place the camera from the focused subject, the greater the depth of field you will have in your image. The closer you place the camera to the focused subject, the shallower depth of field becomes.

3. **Focal length:** Wide-angle focal lengths give greater apparent depth of field, while telephoto focal lengths lessen it, creating a background which is out of focus. When you need to have a scene appear sharp from foreground to background, use the smaller focal lengths on your zoom or change to a wide-angle lens. If you want to limit sharpness and create a shallow depth of field, use the telephoto end of your zoom, or a dedicated telephoto lens.

Lens Speed

Another aspect of lens aperture is speed. Whether a lens is considered "fast" or not is based on its largest available aperture. Lenses with larger maximum aperture openings like f/2.8 are more expensive and considered faster than lenses with smaller maximum apertures like f/4. The larger the aperture opening, the more light a lens can let in, which allows for faster shutter speeds to be used.

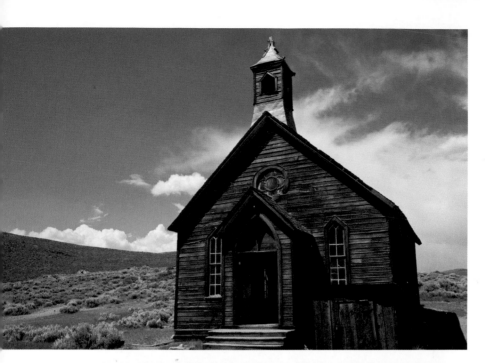

✂ **Top:** Using a small aperture opening (like f/11) and a wide-angle focal length gave this
picture of an old church large depth of field. The photo is in sharp focus from the foreground
to the background.

✂ **Bottom:** Using a large aperture opening (like f/2.8) and a close focusing distance gave this
image shallow depth of field.

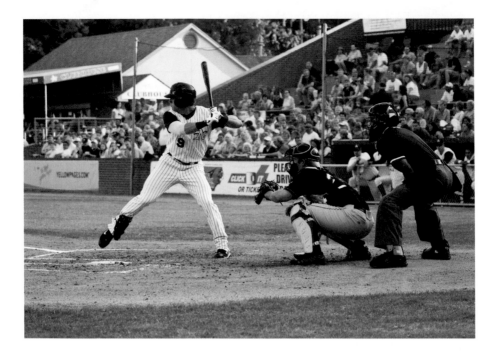

Shutter Speeds

Interpreting movement in pictures is one of the most important creative choices photographers make. If you're photographing moving traffic at night, do you want the cars to appear tack sharp and still so you give a very literal interpretation of the scene, or do you want to let all of the lights blur and streak across the picture, relaying the subjects' motion? The choice, of course, depends on your creative intentions.

D-SLR cameras offer a broad range of shutter speed choices, from very short speeds like 1/2000 second, which is fast enough to stop a hummingbird's wings, to exposures that are many seconds long. These longer shutter speeds are perfect for blurring action, suggesting motion, and getting that soft, pillowy effect popular in pictures of streams and waterfalls.

One of the best ways to learn about shutter speed durations and how they affect your images is to set up an experiment. Use a household object where you can control its speed, like a fan, and try shooting it at different shutter speeds while in Shutter priority mode. This will give you a good basic concept of what speeds stop motion and what speeds significantly blur it. If you'd like to try a more interesting subject, try finding a waterfall, stream, or fountain and see the changes various shutter speeds can make in capturing water. Use a tripod for the longer shutter speeds to eliminate the camera shake caused by handholding.

Panning is another interesting aspect of shutter speed that is fun to play with. Using this method, you choose a moderately long shutter speed and take a picture of a subject in motion. But instead of holding the camera still, you follow the subject as it moves. If done correctly (and it does take some practice), the result is a sharp subject with a blurred background. Images like this are great at implying lots of motion.

✂ Using a long shutter speed will slow the motion of moving objects, which can create all kinds of interesting effects. Here, the lights of cars on the freeway create long streaks of light.

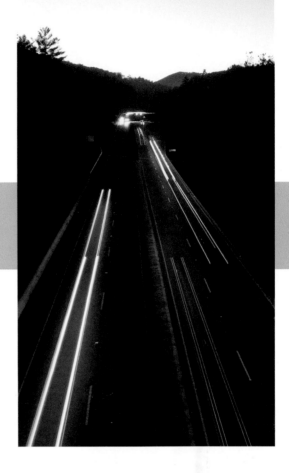

✂ Panning is accomplished by selecting a slow shutter speed and following the path of a moving object with the camera. This keeps the subject in focus while the background is blurred.

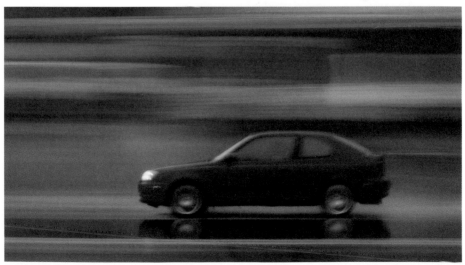

By this point in the book, it should be obvious that a lot more goes into good photography than putting the camera on Auto mode and taking a picture. To get pleasing results, good photography is a combination of composing a good shot and choosing the right settings to reflect the scene and the intention you are trying to convey. This section will look into some of the most popular subjects in photography and recommend the best ways to capture the images you want.

Architecture

Many hobbyists enjoy shooting architecture. When photographing tall buildings, it can be difficult to get interesting shots from the ground looking up. To avoid the common mistake of vertical lines converging, use a telephoto lens and get farther from the building. If using a wide-angle lens, try standing on higher ground like a bank or park bench. In either case, use a small aperture to get good depth of field and a tripod to help steady the shot. For interior shots, use a wide-angle lens so you can capture tight spaces better, and use a small aperture for larger depth of field. Pay close attention to the lighting; it's hard to properly expose interiors and bright sunlit windows in the same shot.

Astronomy

It's interesting to try and capture the arcing motion of the stars through the night sky. To achieve this, you'll need to use a camera mounted on a tripod and a very long shutter speed of up to four hours. Consult your camera's manual to see how to set long shutter speeds. Also, use a low ISO setting like 100.

Children

Think of the best pictures of kids you've seen. What do they all have in common? They are shot at the child's eye level, not the adult's. The first rule in child photography is to get to their level; this erases the statement a high camera position makes, which is to make a child look small and unimportant. A child's facial features are also affected when shot from above because of foreshortening. Use the Portrait mode in your camera and fill flash if necessary to decrease high contrast shadow areas.

✖ **For pictures of children, try getting down to their level.**

Families

For indoor family gatherings, use an accessory flash mounted in the camera's hot shoe. This will decrease red-eye and also allow you to use bounce flash, where you direct the flash at the ceiling or wall near your subjects and the diffused light projects more naturally over them. Use a small zoom lens or focal lengths between 28mm and 135mm. The longer end of this range will work best when combined with bounce flash when the flash range needs to be extended, like when shooting subjects down the length of a long dinner table. If shooting group shots, try positioning people in rows by height so everyone's face can be seen. Having subjects turn their bodies in ¾ profile also helps make more space to get everyone in the shot.

Flowers

Try using the Close-up mode on your camera and a telephoto or zoom lens with a length over 100mm. Using a telephoto lens will allow you to better throw the background out of focus using shallow depth of field. This is pleasing in close-up pictures of flowers because it focuses attention to sharp details while minimizing background distractions.

Landscapes

Use the Landscape mode on your camera and a wide-angle lens, or a small focal length on a zoom lens. If you don't use the Landscape mode, be sure to use a small aperture to get the greatest depth of field possible. When composing your shot, make sure there are no distractions in the foreground that will compete for attention with the broader view. If

you are not shooting in Landscape mode, use evaluative metering to get the best exposure for all parts of the scene.

Portraits

Shooting portraits is similar to the suggestions for shooting children or groups. Put your camera on Portrait mode and use a "portrait lens," or something in the focal length area of 100mm. Frame the subject with just their head and shoulders or their head and torso showing so you can really capture their personality up close. Use bounce flash or fill flash if needed to lighten dark shadows. Make sure that the focus is on the subject's eyes.

Sports

Set your camera to its Sports mode; the icon for this mode usually looks like a person running. If you don't want to use the Sports mode, choose Shutter Priority and select a fast shutter speed like 1/1000 second to stop the action. For most sports, a telephoto or even super-telephoto lens is needed to get up close to the action without actually standing in it. Another consideration is where to position yourself. For many sports, shooting near the goal produces the best action shots. For particularly fast sports, you may want to use the Continuous shooting mode so you can capture multiple frames per second and improve your chances of getting the best image.

GOING FORWARD

At its core, photography is about experimentation. Without it, a photographer never learns to press beyond their comfort level (or auto mode) and explore new techniques that will add dimension to their work. It is through trial and error that almost all parts of the photographic process are learned, so don't be afraid to go out and fail. You don't have to share your work with anyone until you've got images you're proud of. And the best thing about digital photography is you can shoot 10 pictures or 10,000 and it will cost you the same amount—nothing! So go out and change your aperture, white balance, and ISO settings and see what happens. And most important—remember to have fun!

COMMON DIGITAL TERMS

aberration
An optical flaw in a lens that causes the image to be distorted or unclear.

Adobe Photoshop
Professional-level image-processing software with extremely powerful filter and color-correction tools. It offers features for photography, graphic design, web design, and video.

angle of view
The area seen by a lens, usually measured in degrees across the diagonal of the film frame.

aperture
The opening in the lens that allows light to enter the camera. Aperture is usually described as an f/number. The higher the f/number, the smaller the aperture; and the lower the f/number, the larger the aperture.

aperture-priority mode
A type of automatic exposure in which you manually select the aperture and the camera automatically selects the shutter speed.

artifact
Information that is not part of the scene but appears in the image due to technology. Artifacts can occur in film or digital images and include increased grain, flare, static marks, color flaws, noise, etc.

artificial light
Usually refers to any light source that doesn't exist in nature, such as incandescent, fluorescent, and other manufactured lighting.

automatic exposure
When the camera measures light and makes the adjustments necessary to create proper image density on sensitized media.

automatic flash
An electronic flash unit that reads light reflected off a subject (from either a preflash or the actual flash exposure), then shuts itself off as soon as ample light has reached the sensitized medium.

automatic focus
When the camera automatically adjusts the lens elements to sharply render the subject.

available light
The amount of illumination at a given location that applies to natural and artificial light sources but not those supplied specifically for photography. It is also called existing light or ambient light.

backlight
Light that projects toward the camera from behind the subject.

bit depth
The number of bits per pixel that determines the number of colors the image can display. Eight bits per pixel is the minimum requirement for a photo-quality color image.

bracketing
A sequence of pictures taken of the same subject but varying one or more exposure settings, manually or automatically, between each exposure.

buffer

Temporarily stores data so that other programs, on the camera or the computer, can continue to run while data is in transition.

built-in flash

A flash that is permanently attached to the camera body. The built-in flash will pop up and fire in low-light situations when using the camera's automated exposure settings.

built-in meter

A light-measuring device that is incorporated into the camera body.

bulb

A camera setting that allows the shutter to stay open as long as the shutter release is depressed.

CCD

Charge Coupled Device. This is a common digital camera sensor type that is sensitized by applying an electrical charge to the sensor prior to its exposure to light. It converts light energy into an electrical impulse.

CMOS

Complementary Metal Oxide Semiconductor. Like CCD sensors, this sensor type converts light into an electrical impulse. CMOS sensors are similar to CCDs, but allow individual processing of pixels, are less expensive to produce, and use less power. See also, CCD.

CMYK mode

Cyan, magenta, yellow, and black. This mode is typically used in image-editing applications when preparing an image for printing.

color balance

The average overall color in a reproduced image. How a digital camera interprets the color of light in a scene so that white or neutral gray appear neutral.

color cast

A colored hue over the image often caused by improper lighting or incorrect white balance settings. Can be produced intentionally for creative effect.

color space

A mapped relationship between colors and computer data about the colors.

compression

A method of reducing file size through removal of redundant data, as with the JPEG file format.

contrast

The difference between two or more tones in terms of luminance, density, or darkness.

contrast filter

A colored filter that lightens or darkens the monotone representation of a colored area or object in a black-and-white photograph.

critical focus

The most sharply focused plane within an image.

cropping

The process of extracting a portion of the image area. If this portion of the image is enlarged, resolution is subsequently lowered.

dedicated flash

An electronic flash unit that talks with the camera, communicating things such as flash illumination, lens focal length, subject distance, and sometimes flash status.

default

Refers to various factory-set attributes or features, in this case of a camera, that can be changed by the user but can, as desired, be reset to the original factory settings.

depth of field

The image space in front of and behind the plane of focus that appears acceptably sharp in the photograph.

dpi

Dots per inch. Used to define the resolution of a printer, this term refers to the number of dots of ink that a printer can lay down in an inch.

electronic flash

A device with a glass or plastic tube filled with gas that, when electrified, creates an intense flash of light. Also called a strobe. Unlike a flash bulb, it is reusable.

electronic rangefinder

A system that utilizes the AF technology built into a camera to provide a visual confirmation that focus has been achieved. It can operate in either manual or AF focus modes.

EV

Exposure value. A number that quantifies the amount of light within an scene, allowing you to determine the relative combinations of aperture and shutter speed to accurately reproduce the light levels of that exposure.

EXIF

Exchangeable Image File Format. This format is used for storing an image file's interchange information.

exposure

When light enters the camera and reacts with the sensitized medium. The term can also refer to the amount of light that strikes the light sensitive medium.

file format

The form in which digital images are stored and recorded, e.g., JPEG, RAW, TIFF, etc.

filter

Usually a piece of plastic or glass used to control how certain wavelengths of light are recorded. A filter absorbs selected wavelengths, preventing them from reaching the light sensitive medium. Also, software available in image-processing computer programs can produce special filter effects.

firmware

Software that is permanently incorporated into a hardware chip. All computer-based equipment, including digital cameras, use firmware of some kind.

flare

Unwanted light streaks or rings that appear in the viewfinder, on the recorded image, or both. It is caused by extraneous light entering the camera during shooting. Filters can also increase flare. Use of a lens hood can often reduce this undesirable effect.

focal length

When the lens is focused on infinity, it is the distance from the optical center of the lens to the focal plane.

focal plane

The plane on which a lens forms a sharp image. Also, it may be the film plane or sensor plane.

focus

An optimum sharpness or image clarity that occurs when a lens creates a sharp image by converging light rays to specific points at the

focal plane. The word also refers to the act of adjusting the lens to achieve optimal image sharpness.

f/stop

The size of the aperture or diaphragm opening of a lens, also referred to as f/number or stop. The term stands for the ratio of the focal length (f) of the lens to the width of its aperture opening. (f/1.4 = wide opening and f/22 = narrow opening.) Each stop up (lower f/number) doubles the amount of light reaching the sensitized medium. Each stop down (higher f/number) halves the amount of light reaching the sensitized medium.

full-sized sensor

A sensor in a digital camera that has the same dimensions as a 35mm film frame (24 x 36 mm).

GB (gigabyte)

Just over one billion bytes.

gray card

A card used to take accurate exposure readings. It typically has a white side that reflects 90% of the light and a gray side that reflects 18%.

gray scale

A successive series of tones ranging between black and white, which have no color.

guide number (GN)

A number used to quantify the output of a flash unit. It is derived by using this formula: GN = aperture x distance. Guide numbers are expressed for a given ISO film speed in either feet or meters.

histogram

A graphic representation of image tones.

hot shoe

An electronically connected flash mount on the camera body. It enables direct connection between the camera and an external flash, and synchronizes the shutter release with the firing of the flash.

image-processing program

Software that allows for image alteration and enhancement.

interpolation

Process used to increase image resolution by creating new pixels based on existing pixels. The software intelligently looks at existing pixels and creates new pixels to fill the gaps and achieve a higher resolution.

IS

Image Stabilization. This is a technology that reduces camera shake and vibration. It is used in lenses, binoculars, camcorders, etc.

ISO

From isos (Greek for equal), a term for industry standards from the International Organization for Standardization. When an ISO number is applied to film, it indicates the relative light sensitivity of the recording medium. Digital sensors use film ISO equivalents, which are based on enhancing the data stream or boosting the signal.

kilobyte (KB)

Just over one thousand bytes.

latitude

The acceptable range of exposure (from under to over) determined by observed loss of image quality.

lens hood

Also called a lens shade. This is a short tube that can be attached to the front of a lens to reduce flare. It keeps undesirable light from reaching the front of the lens and also protects the front of the lens.

light meter

Also called an exposure meter, it is a device that measures light levels and calculates the correct aperture and shutter speed.

macro lens

A lens designed to be at top sharpness over a flat field when focused at close distances and reproduction ratios up to 1:1.

main light

The primary or dominant light source. It influences texture, volume, and shadows.

manual exposure mode

A camera operating mode that requires the user to determine and set both the aperture and shutter speed. This is the opposite of automatic exposure.

mbps

Megabits per second. This unit is used to describe the rate of data transfer.

megabyte (MB)

Just over one million bytes.

megapixel (MP)

A million pixels.

menu

A listing of features, functions, or options displayed on a screen that can be selected and activated by the user.

middle gray

Halfway between black and white, it is an average gray tone with 18% reflectance. See also, gray card.

midtone

The tone that appears as medium brightness, or medium gray tone, in a photographic print.

mode

Specified operating conditions of the camera or software program.

noise

The digital equivalent of grain. It is often caused by a number of different factors, such as a high ISO setting, heat, sensor design, etc. Though usually undesirable, it may be added for creative effect using an image-processing program. See also, chrominance noise and luminance.

overexposed

When too much light is recorded with the image, causing the photo to be too light in tone.

perspective

The effect of the distance between the camera and image elements upon the perceived size of objects in an image. It is also an expression of this three-dimensional relationship in two dimensions.

pixel

Derived from picture element. A pixel is the base component of a digital image. Every individual pixel can have a distinct color and tone.

plug-in

Third-party software created to augment an existing software program.

polarization

An effect achieved by using a polarizing filter. It minimizes reflections from non-metallic surfaces like water and glass and saturates colors by removing glare. Polarization often makes skies appear bluer at 90 degrees to the sun. The term also applies to the above effects simulated by a polarizing software filter.

program mode

In Program exposure mode, the camera selects a combination of shutter speed and aperture automatically.

rear curtain sync

A feature that causes the flash unit to fire just prior to the shutter closing. It is used for creative effect when mixing flash and ambient light.

resolution

The amount of data available for an image as applied to image size. It is expressed in pixels or megapixels, or sometimes as lines per inch on a monitor or dots per inch on a printed image.

RGB mode

Red, Green, and Blue. This is the color model most commonly used to display color images on video systems, film recorders, and computer monitors. It displays all visible colors as combinations of red, green, and blue. RGB mode is the most common color mode for viewing and working with digital files on screen.

sharp

A term used to describe the quality of an image as clear, crisp, and perfectly focused, as opposed to fuzzy, obscure, or unfocused.

shutter

The apparatus that controls the amount of time during which light is allowed to reach the sensitized medium.

Shutter-priority mode

An automatic exposure mode in which you manually select the shutter speed and the camera automatically selects the aperture.

slow sync

A flash mode in which a slow shutter speed is used with the flash in order to allow low-level ambient light to be recorded by the sensitized medium.

small-format sensor

In a digital camera, this sensor is physically smaller than a 35mm frame of film. The result is that standard 35mm focal lengths act like longer lenses because the sensor sees an angle of view smaller than that of the lens.

stop down

To reduce the size of the diaphragm opening by using a higher f/number.

stop up

To increase the size of the diaphragm opening by using a lower f/number.

strobe

Abbreviation for stroboscopic. An electronic light source that produces a series of evenly spaced bursts of light.

synchronize

Causing a flash unit to fire simultaneously with the complete opening of the camera's shutter.

USB

Universal Serial Bus. This interface standard allows outlying accessories to be plugged and unplugged from the computer while it is turned on. USB 2.0 enables high-speed data transfer.

INDEX